Art From Behind The Walls Of Oklahoma Prisons

PEN AND PENCIL DRAWINGS

BY
KENNETH JOE NORTON

STORY BY
MARSHA NORTON KEITH

KENNETH'S STORY
BY MARSHA KEITH (MOM)

Kenneth was born on January 13, 1978. Two major things were this: it was Friday the 13th and for the first time in over a decade Pine Bluff, Arkansas was buried in a huge amount of snow. No traffic was moving, schools closed and here I was ready to deliver a baby.

Kenneth's dad was at work as a friend picked him up in a huge four-wheel pickup. My mom and sister were there as it was time for me or past time for me to deliver and the doctor had decided to take the baby with a C Section birth if need be but one way or the other that baby was going to be born and on Friday the 13th.

Mom could not get her car out as the roads were not passable enough for her car so my husband sent his friend's son over to pick me up. The young man showed up in a truck that was so high up my mom and sister had to push me up in it.

Kenneth was born after many, many hours of labor and at 8 p.m. he was born on Friday the 13th. Four hours later would have been the 14th and my dad's birthday but Kenneth was ready and I was oh so ready to have this baby.

From the age of three Kenneth was a handful he seemed to not want to go by any one's rules.

I took him to a very good pediatrician who said due to my ex-husband drug use Kenneth had a chemical imbalance and was diagnosed with several issues.

He was loving child with a very stubborn manner.

As he got older we had good times and bad times and being a single mom was hard at times, very hard but I would not have had another child for any thing.

His sister sometimes was the brunt of his moods and this was the hardest for me to take but he loved her and would stand up for her if thought any one else was doing her wrong.

Kenneth was an angry child but he had love for many things and was gentle to: animals, his Gran, and other kids who were being picked on or made fun of and could not stand up for themselves.

 One specific story comes to mind is when he was in ninth grade and I would walk with him to bus stop; I wanted to make sure he got on bus as in Antlers public school I would walk him to front door and he would walk out back and play hokey. This day he was getting on bus when another student made fun of my limp, which I have due to a disability. Well, without thinking of the consequences he slugged the boy. The bus driver told him later he understood and did not disagree but he should have waited till he the bus driver was not looking. Savanna schools had no experience or desire to provide education to a boy with Ken's issues so they found every excuse to suspend him till one day they expelled him over the excuse of carrying dip tobacco to school. By the way they never found it on him. I did not know but do now they could not expel for that only drugs or violence but let them ruin his life and make him suffer another blow to his ego.

I sent him to McAlester Public Schools and he was placed in the classroom for children with emotional issues. He was doing well and he loved the teacher who a kind and gentle soul. He even then displayed a talent for art as shown by the fact that the students were to right a story and do some form of illustrations. Once the others saw his art they all wanted him to do their illustrations.

The then principal decided on his own that Kenneth did not meet the criteria for the classroom and sent him against my better wishes to the alternative school system in McAlester.

Here he was introduced to boys who would show him a life of excitement and worse danger and crime. He was 15 years old in a class with boys 17 and 18 who some had juvenile records, bad records.

He was being picked on by some of the juveniles in his class as well as the teacher. I had to call the superintendent of schools to get her to get teacher to apologize to Kenneth in front of class about remarks he made about his big feet and wearing parachute pants and his pink T shirt that he got for the March of Dimes Walkathon. I was so lost how to help this child.

Kenneth began running with these boys and doings things I knew nothing about till too late. He came in after curfew and I paid the fines.

He also got involved with some older boys from the country and pulled a juvenile crime, which got him community service. I pleaded for help and got none from Juvenile Services.

Kenneth got just angrier and angrier and would some times lash out at me physically. It was like a light switch going off in his head and then coming back on. He had no recollection of what he did while the switch was off.

He had no interest in school and just was being passed by, as this school really had no interest in helping these kids who did not fit the criteria for normal public school.

Kenneth behavior became so bad that it was recommended he go to a treatment center for children with behavioral issues.

Kenneth was easily influenced and acted first then thought it out later, which proved to be disastrous for him.

Kenneth and several other boys decided to run from the treatment center and while crossing the street was hit by a drunk driver.

The call in the middle of the night came. I remember answering and starting conversation with oh you found him. The next words were a blow to my heart. The caller had to inform me that my son, my 15-year-old son was hit by a drunk driver and was being life lined to Joplin Missouri, which was the biggest trauma center closest to Miami, Oklahoma.

I called his aunt, my younger sister and she then called my middle sister who had my daughter with her at that time as my daughter wanted to stay with her older cousin.

The ride was the longest I have ever taken although was no more than six or eight. When we got to hospital my son was in surgery. The surgery was to save his life, it lasted six hours. He was then moved to intensive care where he and I lived for the next month. Ken had two open compound fractures on both legs and one arm, a head injury and more. The doctor says he lost three pints of blood on highway before ambulance got there.

The next year was spent in and out of hospitals trying to save his leg. It was finally decided that his leg must be amputated in order to save his life and so at sixteen thanks to a drunk driver he lost his leg.

Ken was now angrier than ever and found every way possible to vent his anger. Unfortunately, he did it through running with the wrong people and making very stupid mistakes. Mistakes he eventually would pay for by answering to law enforcement.

Kenneth and his girl had a son at ages 17 and at age 18 he went to prison for five years; it could be 2 ½ if he behaved they said. I honestly wanted to believe he did not do what he was convicted of after all why would he need money I was always giving him extra cash for him and the baby.

He served almost whole time, as he could not stay out of wanting to please every one else, which usually consisted of infractions. He was almost 21 when he got out. He had missed the carefree days of teen years and the first three years of his son's life.

During his first few years in prison Kenneth found he liked art and he really had a talent for it. I would receive letters from him and the envelopes would be decorated with some very remarkable art. Inside he would send pictures he had drawn me. I prayed he would do some thing with this art once he got out.

He did well for a while but something inside Kenneth made him need stuff to make him happy, stuff that he could not handle. Kenneth was a child of a drug using, alcoholic dad and this should have taught him to stay away from the stuff but he was drawn to it and trouble like a moth to a flame.

Kenneth seem to lack the self-confidence and self-esteem that was needed to stay away from trouble and the people who attracted trouble or

who he felt he needed to impress by getting in trouble. He was drawn to women who used him for his check or for the fact he would work and not make them. His heart was broken when his son's mother could not wait for him the first time. True, he was not always kind to her and preferred running with his friends over staying at home with her and his son; but as I said they were way to young to have a baby and Kenneth's teenage years were spent in prison so now at 21 he wanted to be a teen.

He spent the next ten years in and out of prison. He seemed to be more at home sad to say in the regimental atmosphere of a prison. His art was beautiful but each time he went I received art like you could not imagine a boy with an eight grade education and no training could do.

I love this boy and inside him is the capability to do good so with courage, determination, support and God's grace he will stay free, do good and be here for those that love him.

BELOW YOU WILL VIEW THE ART OF A BOY NOW A MAN WHO WITH NO TRAINING BUT A LIFE OF PAIN, LOVE, AND HARD KNOCK EXPERIENCES DISPLAYS RAW TALENT. YES AS HIS MOM I AM PREJUDICED BUT THIS IS TALENT AND INSIDE HIM IS A GOOD MAN WITH GREAT TALENT WANTING TO GET OUT AND LIVE AND BE FREE AND HAPPY. GOD BLESS THIS MAN I CALL MY SON.

A POEM FOR MY SON ABOUT MY SON
WRITTEN BACK IN 2000

YOU CALL HIM 250XXX

AS I APPROACH THE COLD GRAY WALLS THAT HOUSE MY SON I FEEL JOY AND YET I FEEL PAIN.
I GIVE YOU A NUMBER FOR THAT IS WHAT YOU KNOW HIM BY.
YOU CALL HIM 250XXX BUT I CALL HIM SON.
A BOY WHO LOVED TO FISH AND CATCH TADPOLES IN THE MUDHOLES AFTER A RAIN. A BOY WHO WAS SO EXCITED AND NERVOUS ABOUT HIS FIRST REAL PROM.
A BOY WHO LOVED ANIMALS AND HAD KINDNESS AND LOVE IN HIM.
YOU CALL HIM 250XXX I CALL HIM SON

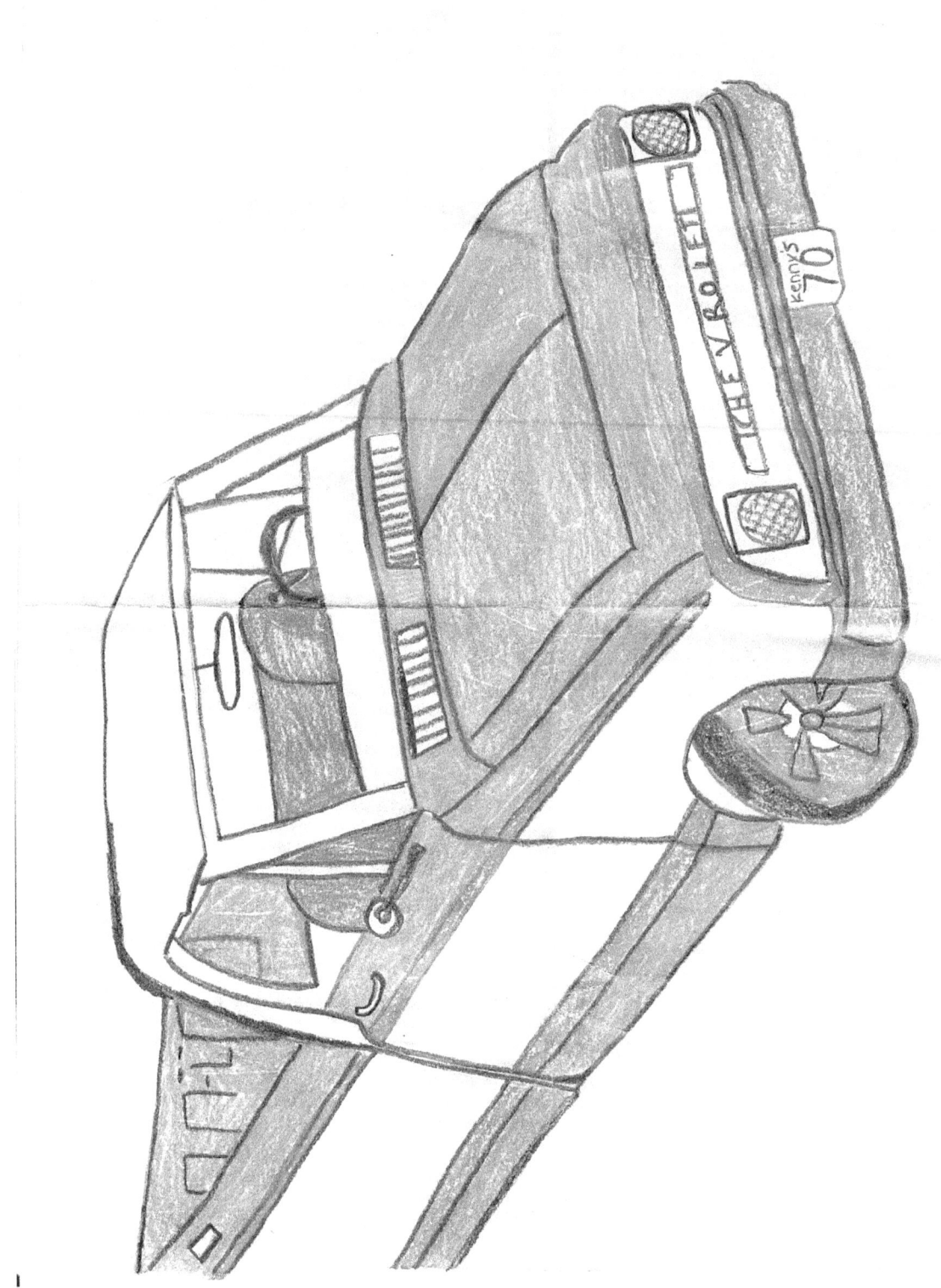

Ken dream truck

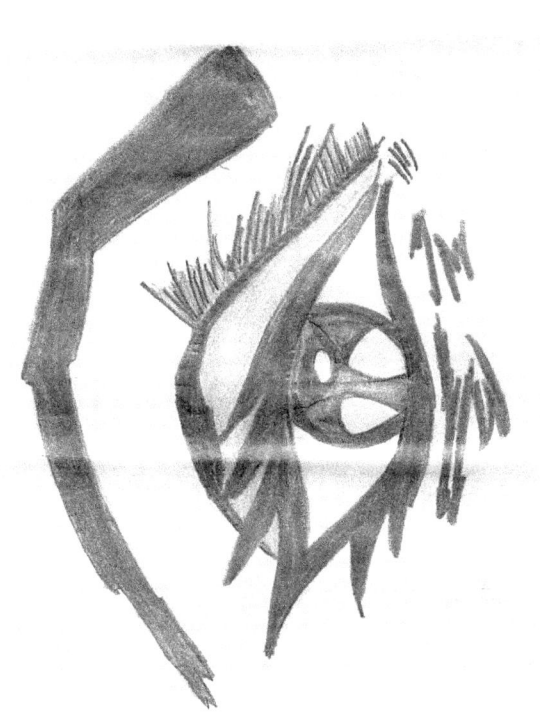

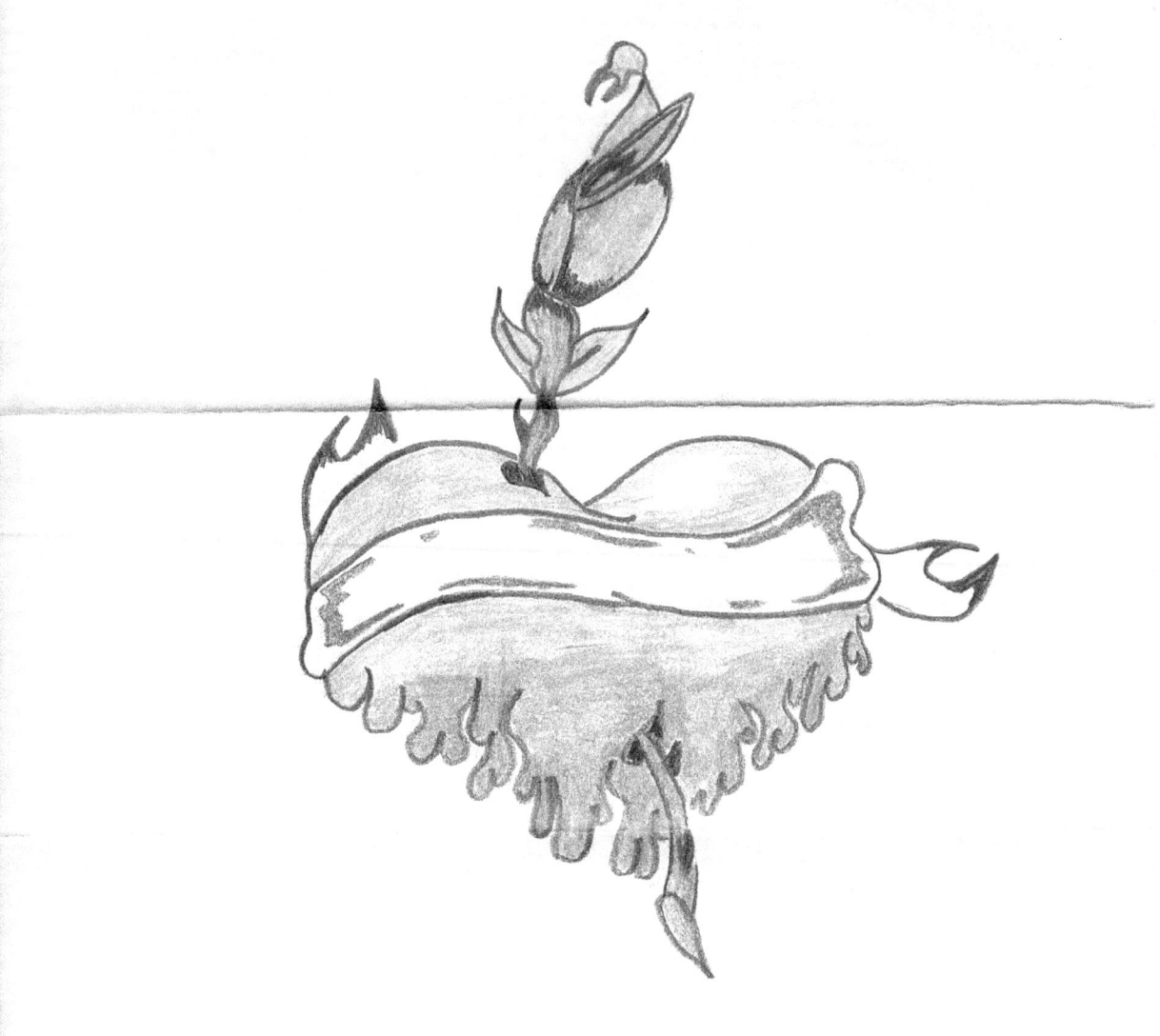

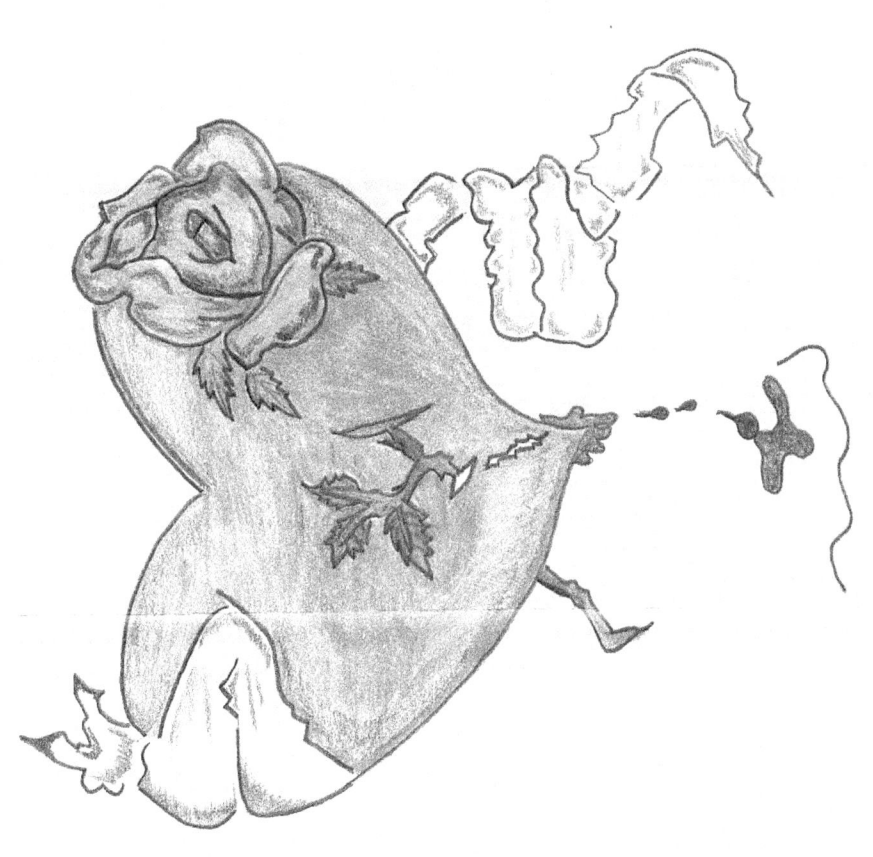

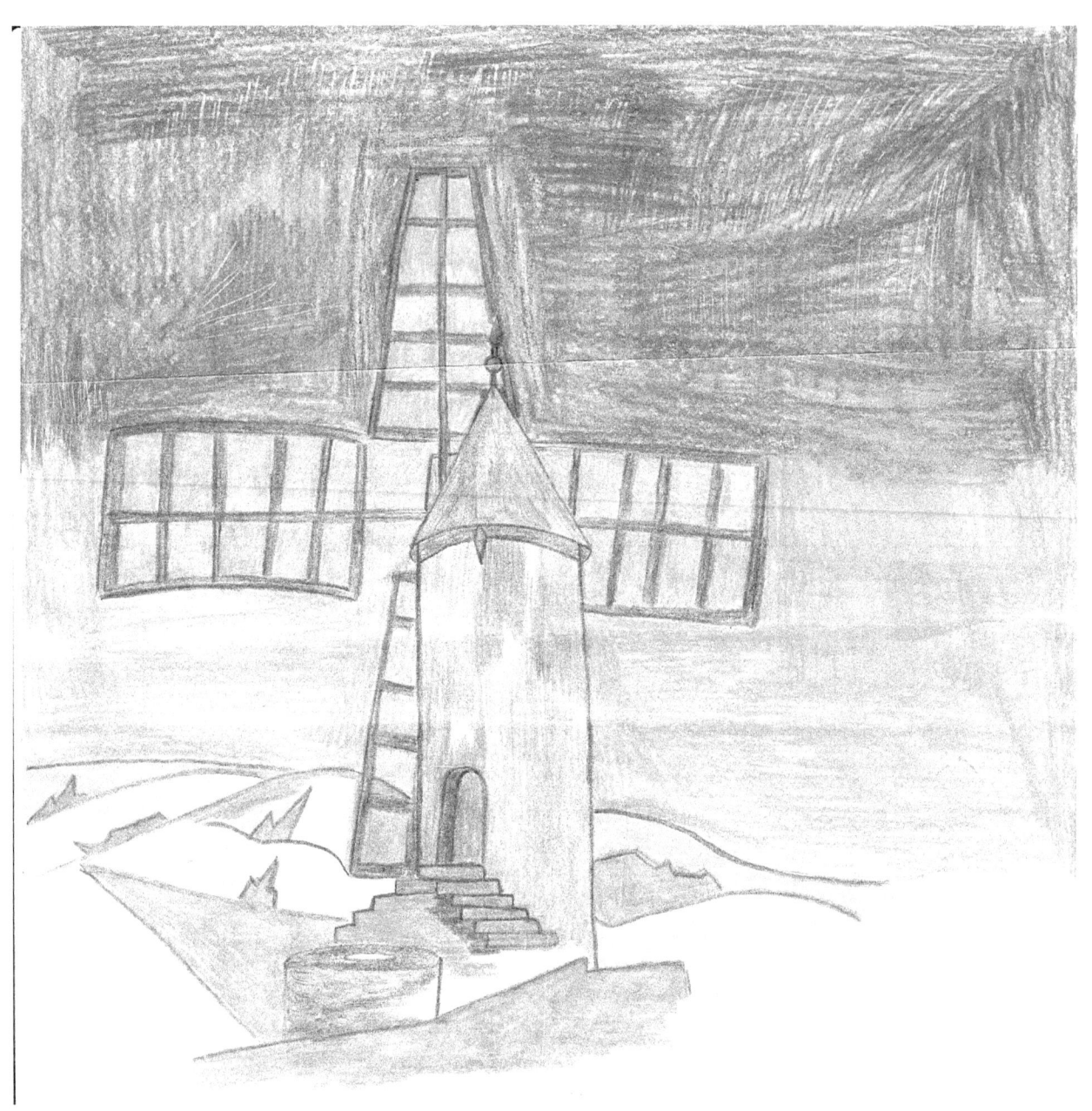

Ken knew I loved lighthouses and windmills so he sent me this

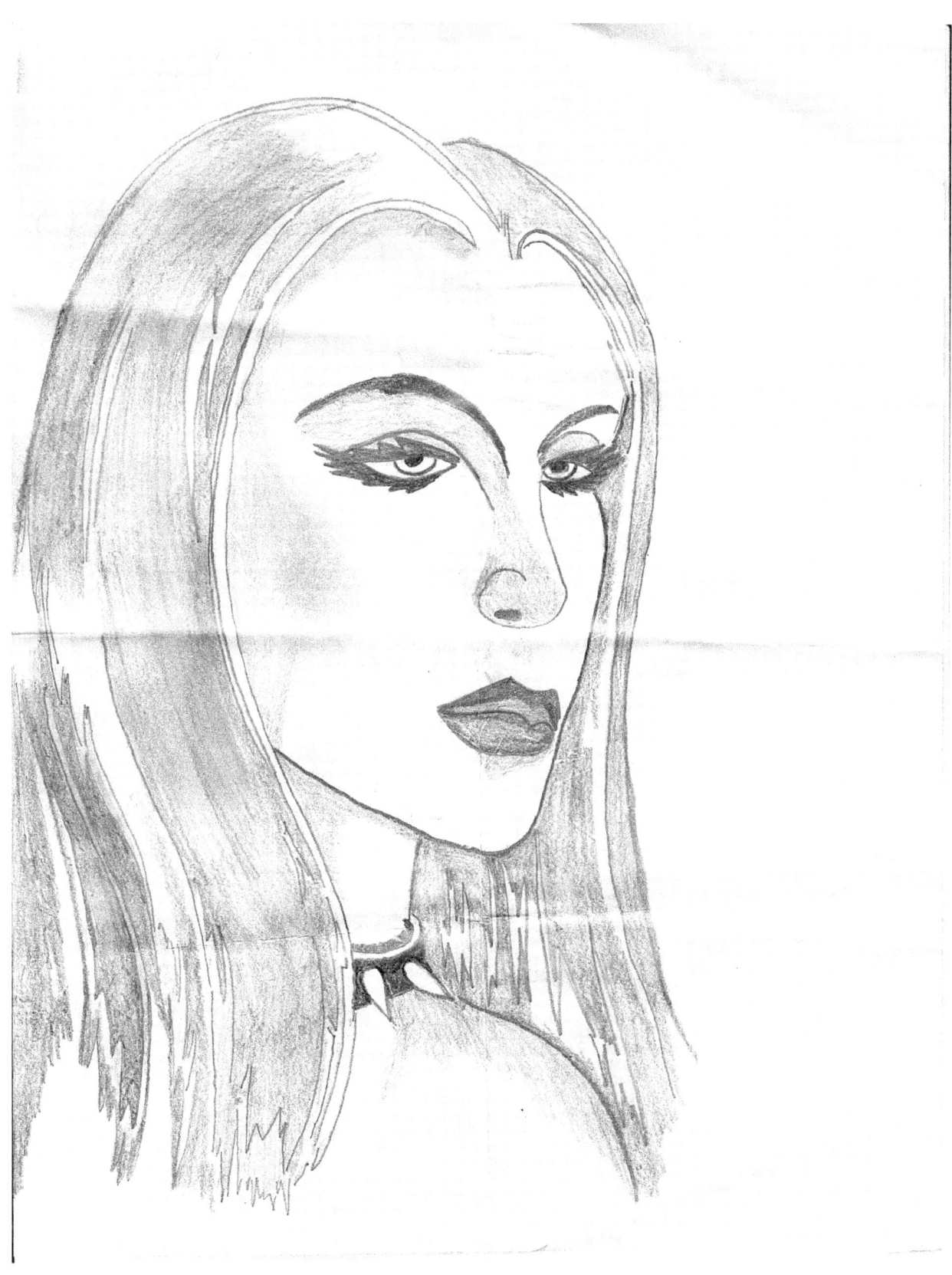

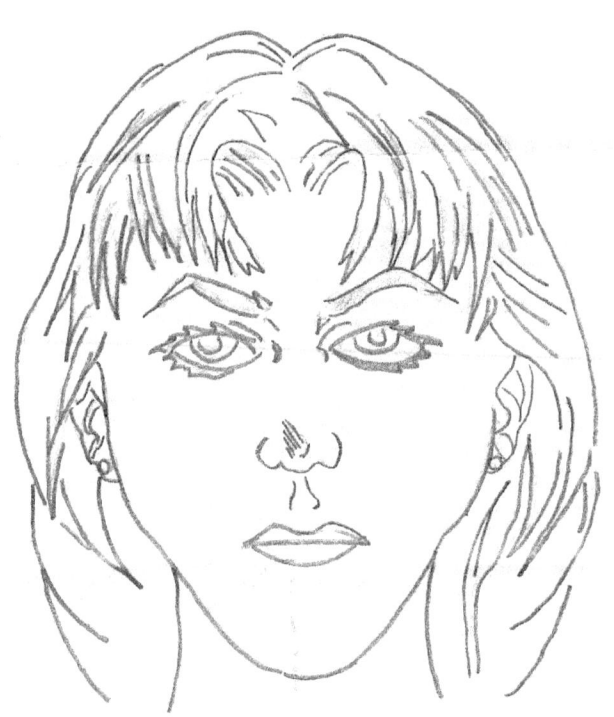

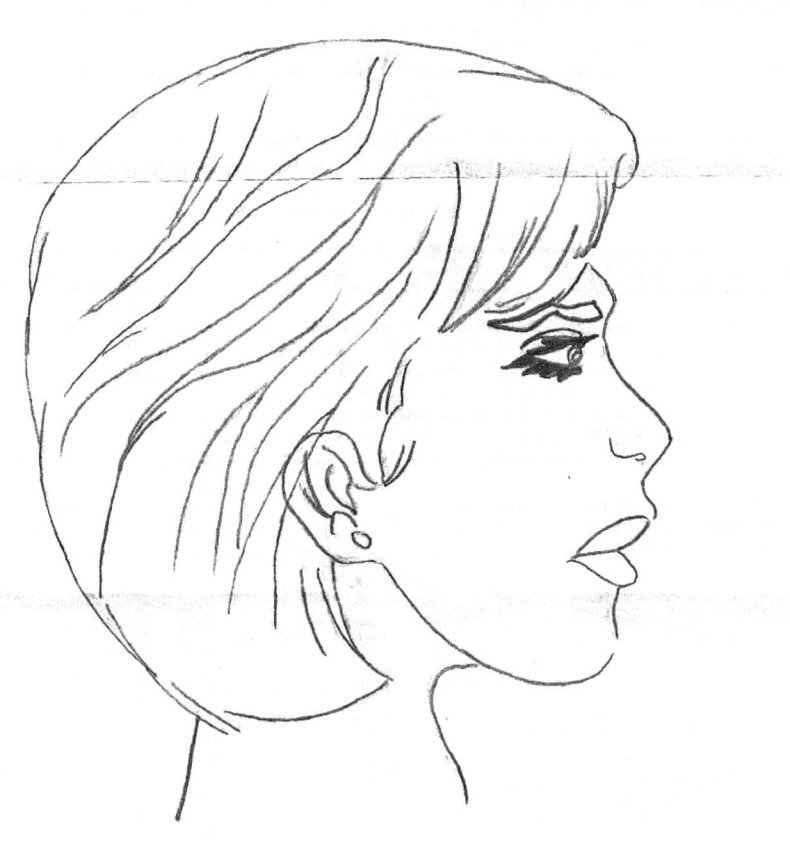

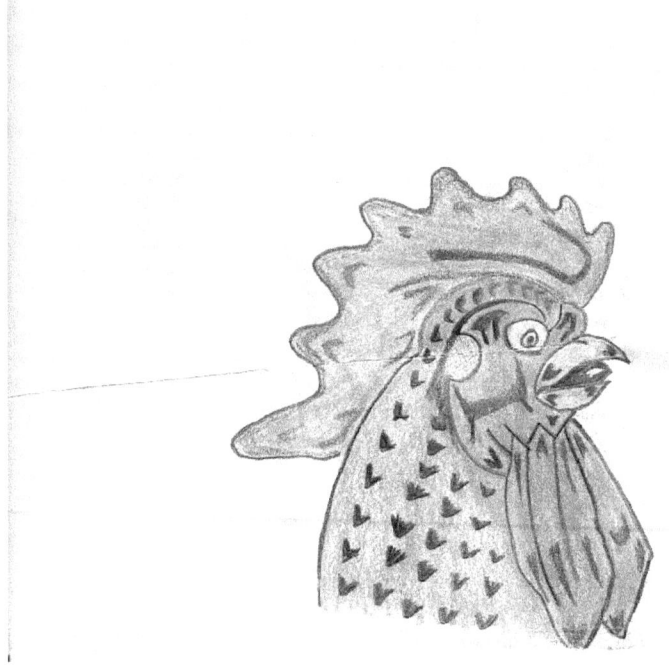

Kenneth loved chickens and as a young boy of nine and ten raised shows chickens and other kinds. He even worked for a man I knew taking care of his chickens with him. He never wanted to collect the eggs from his chickens and before we knew it we had over 100 chickens. We had to tone it down to just show chickens and one old hen. It was so hard for him to get rid of them.

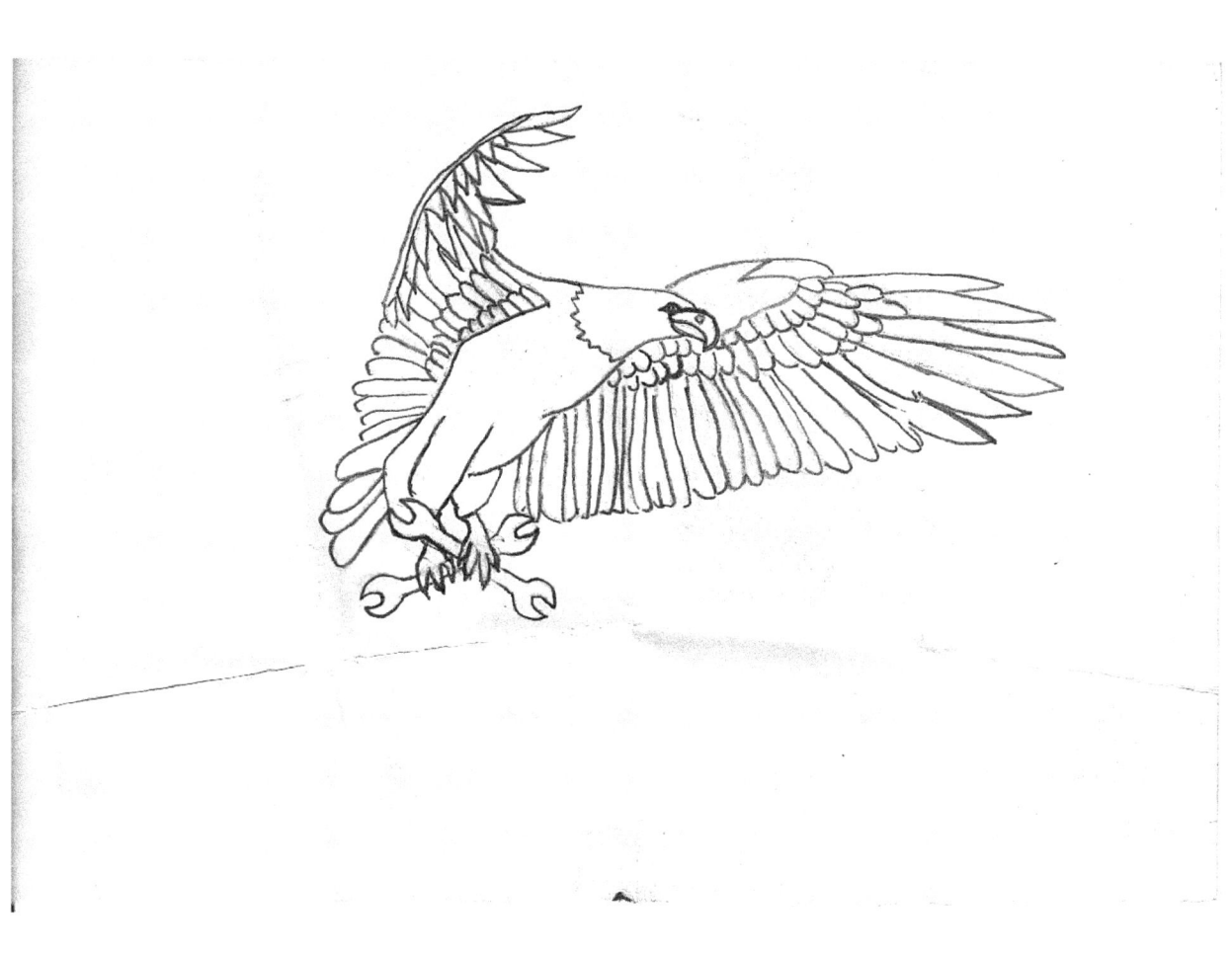

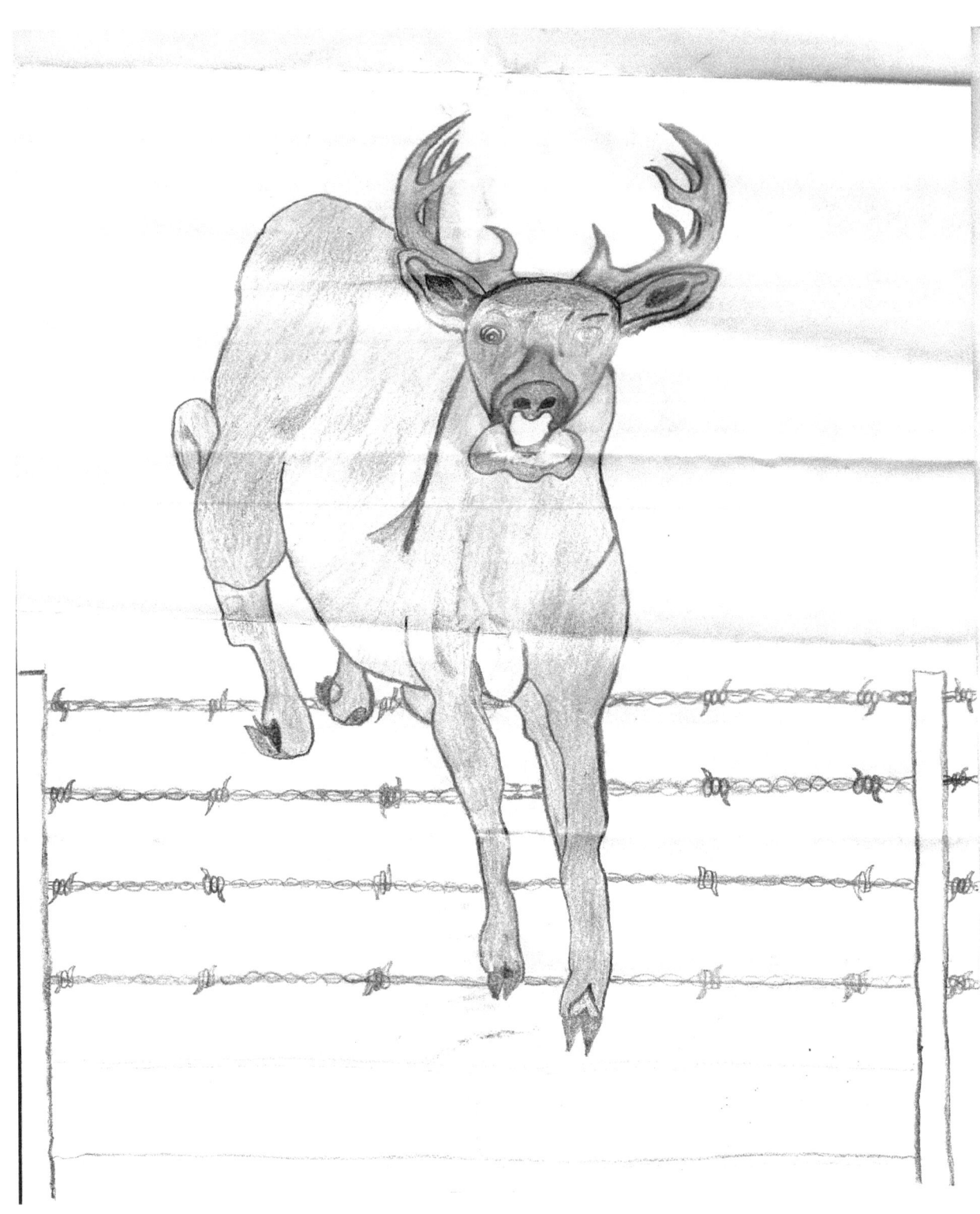

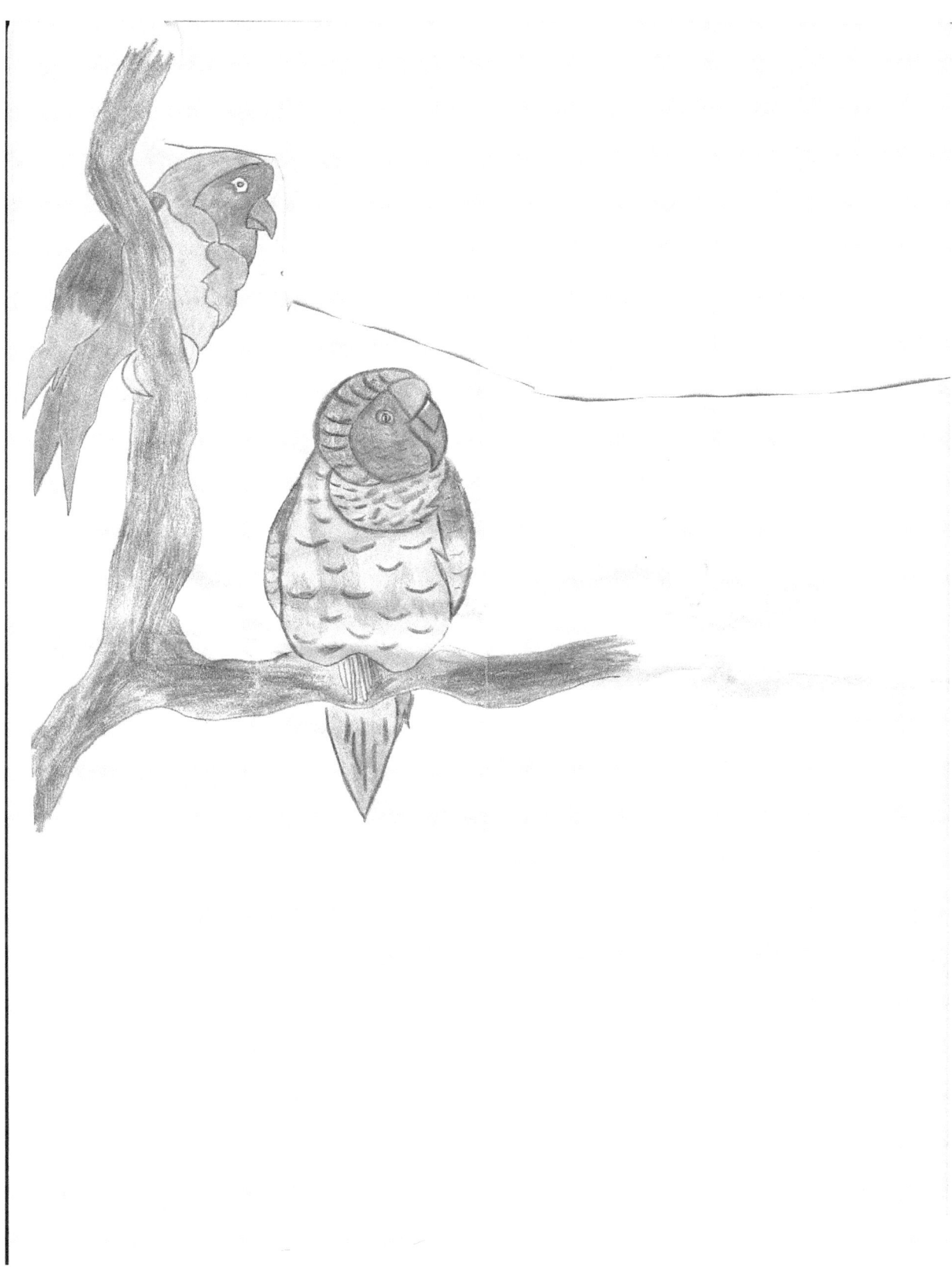

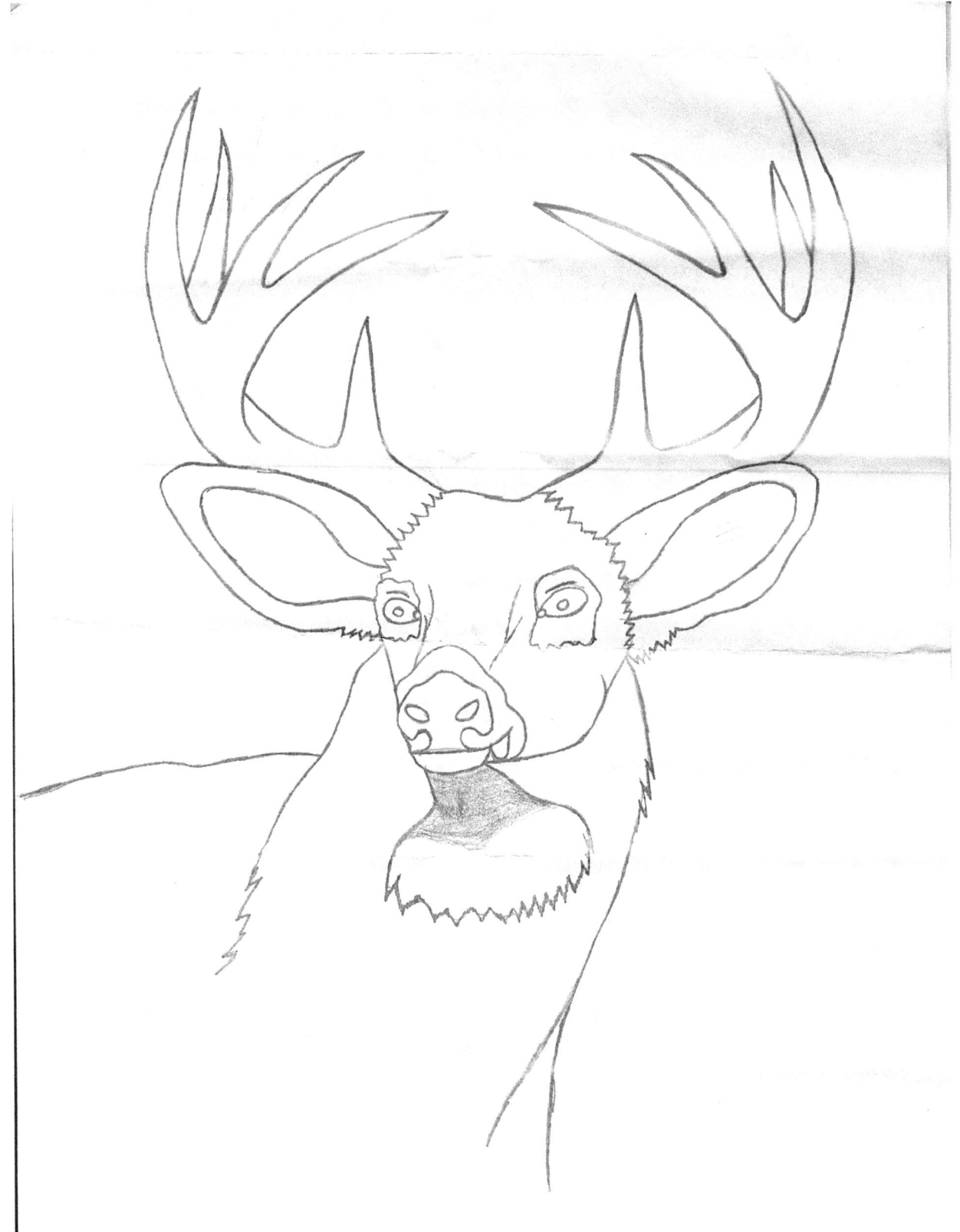

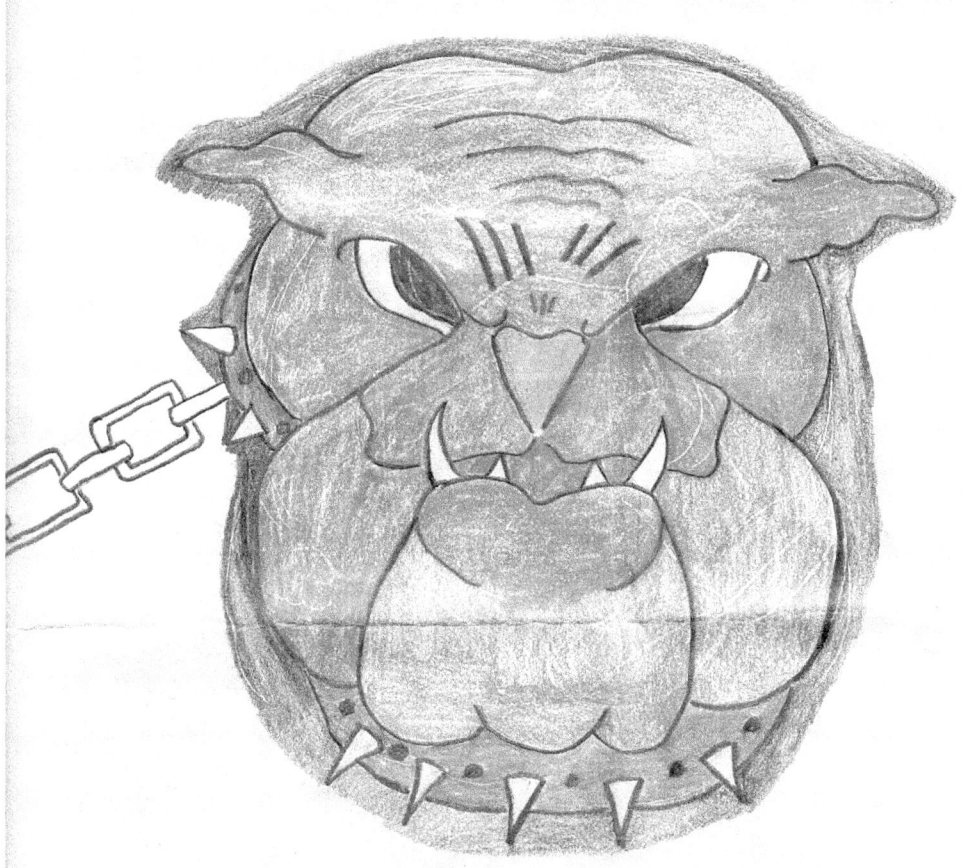

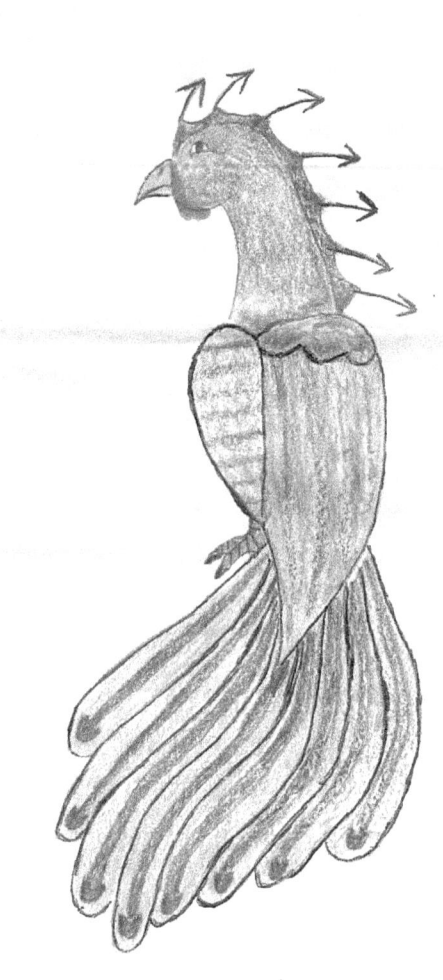

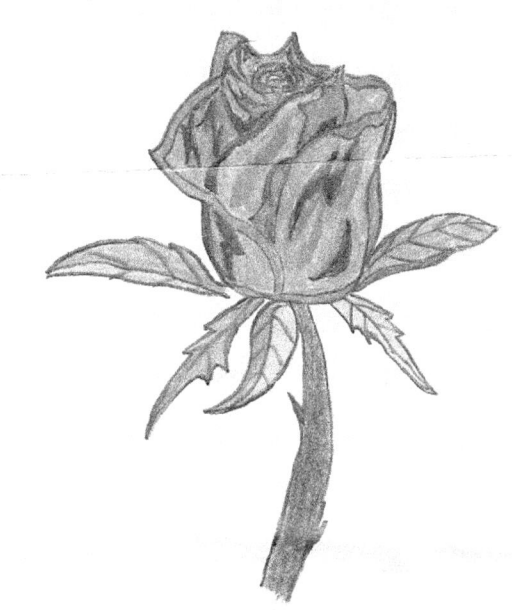

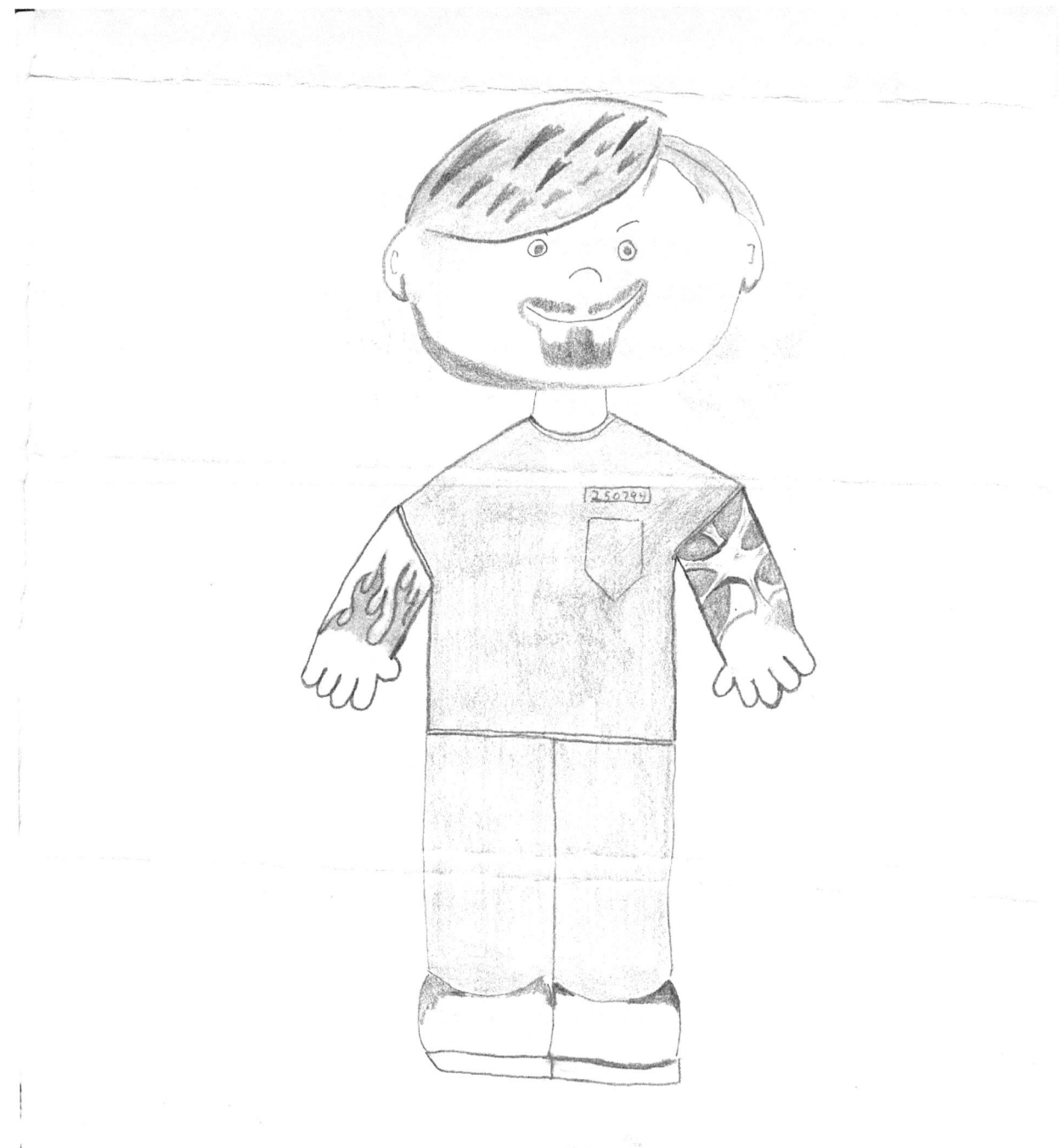

Kenneth idea of a cartoon self-portrait.

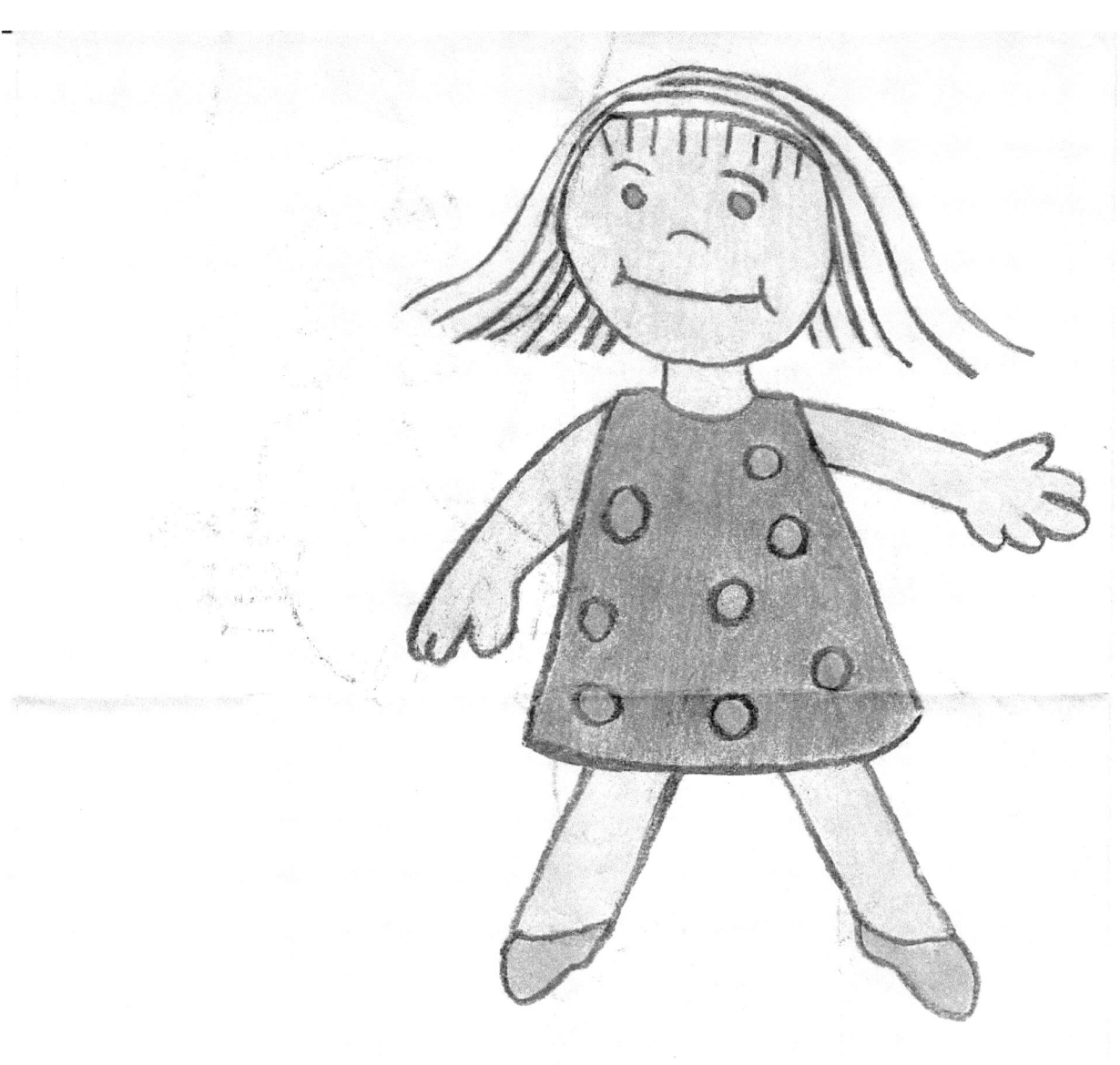

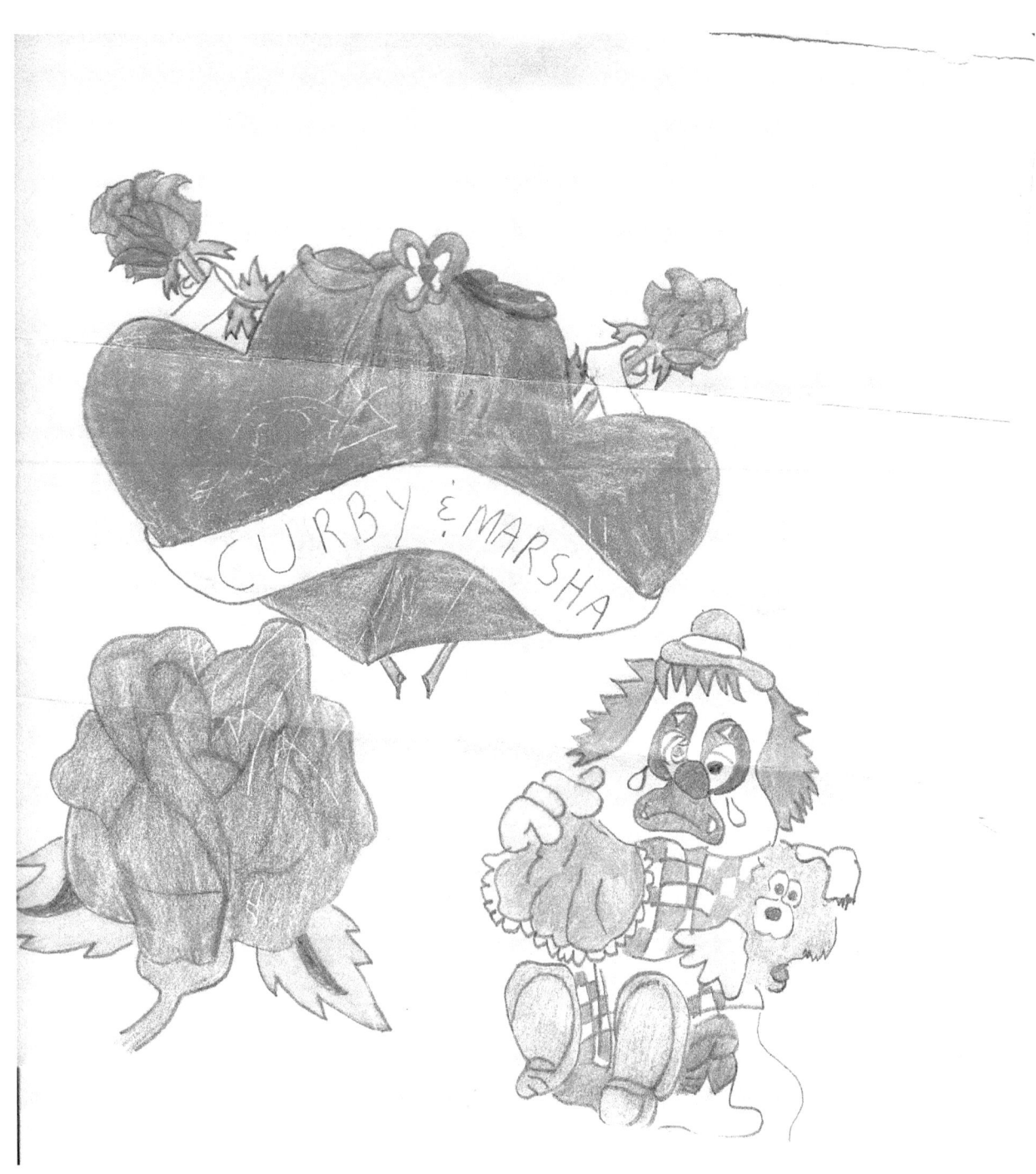

Images from cards he has sent his step-dad and me.

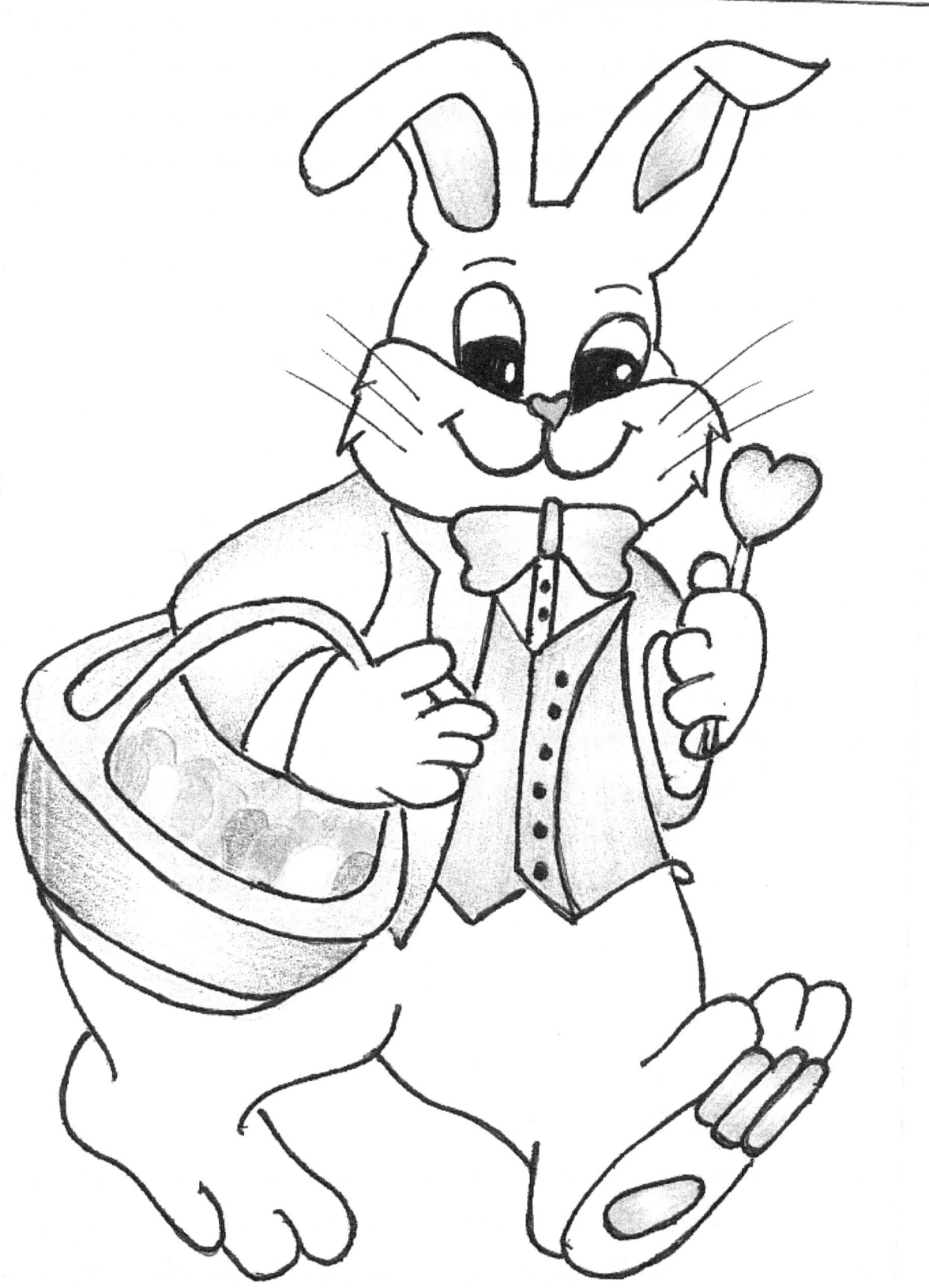

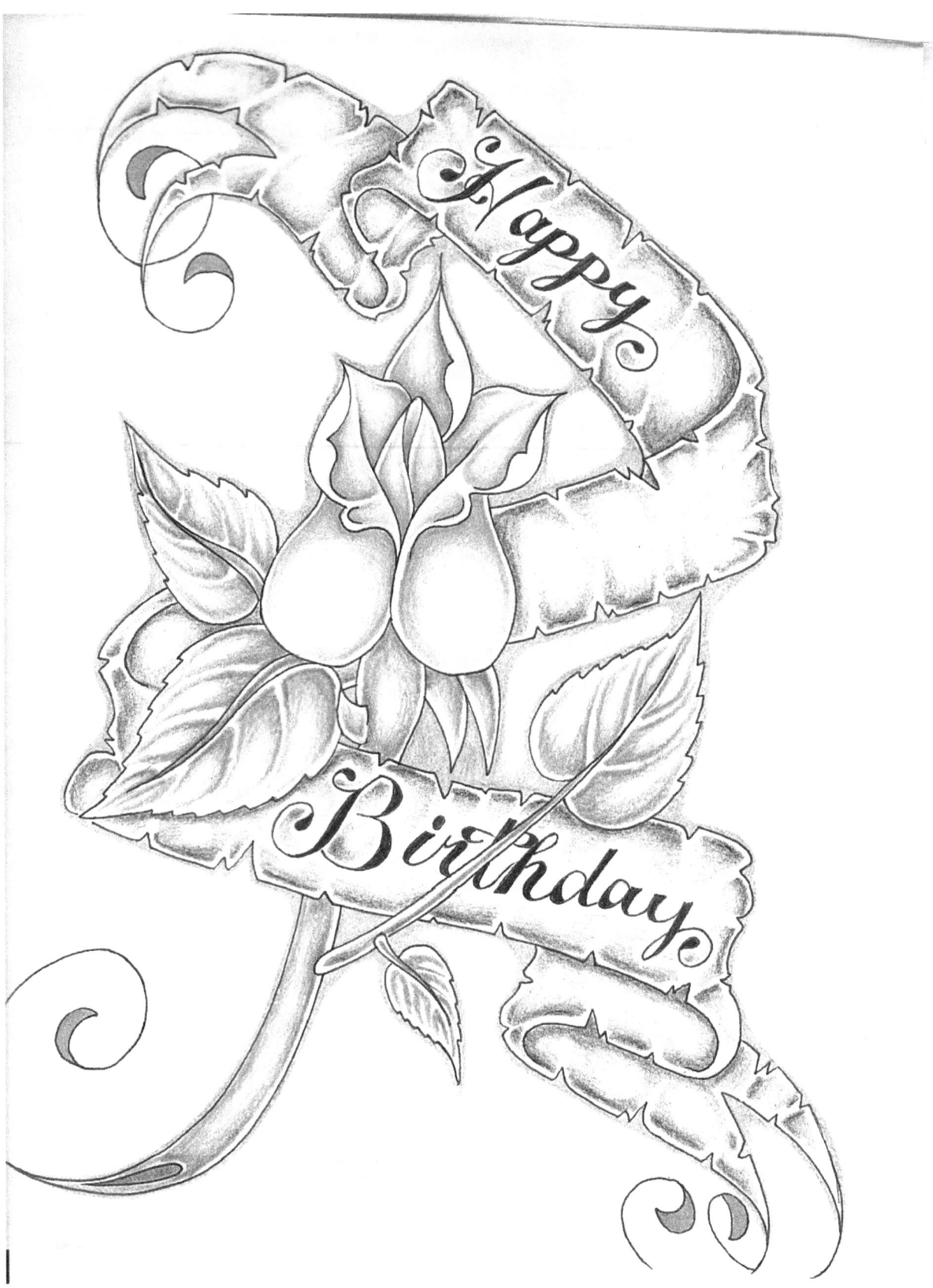

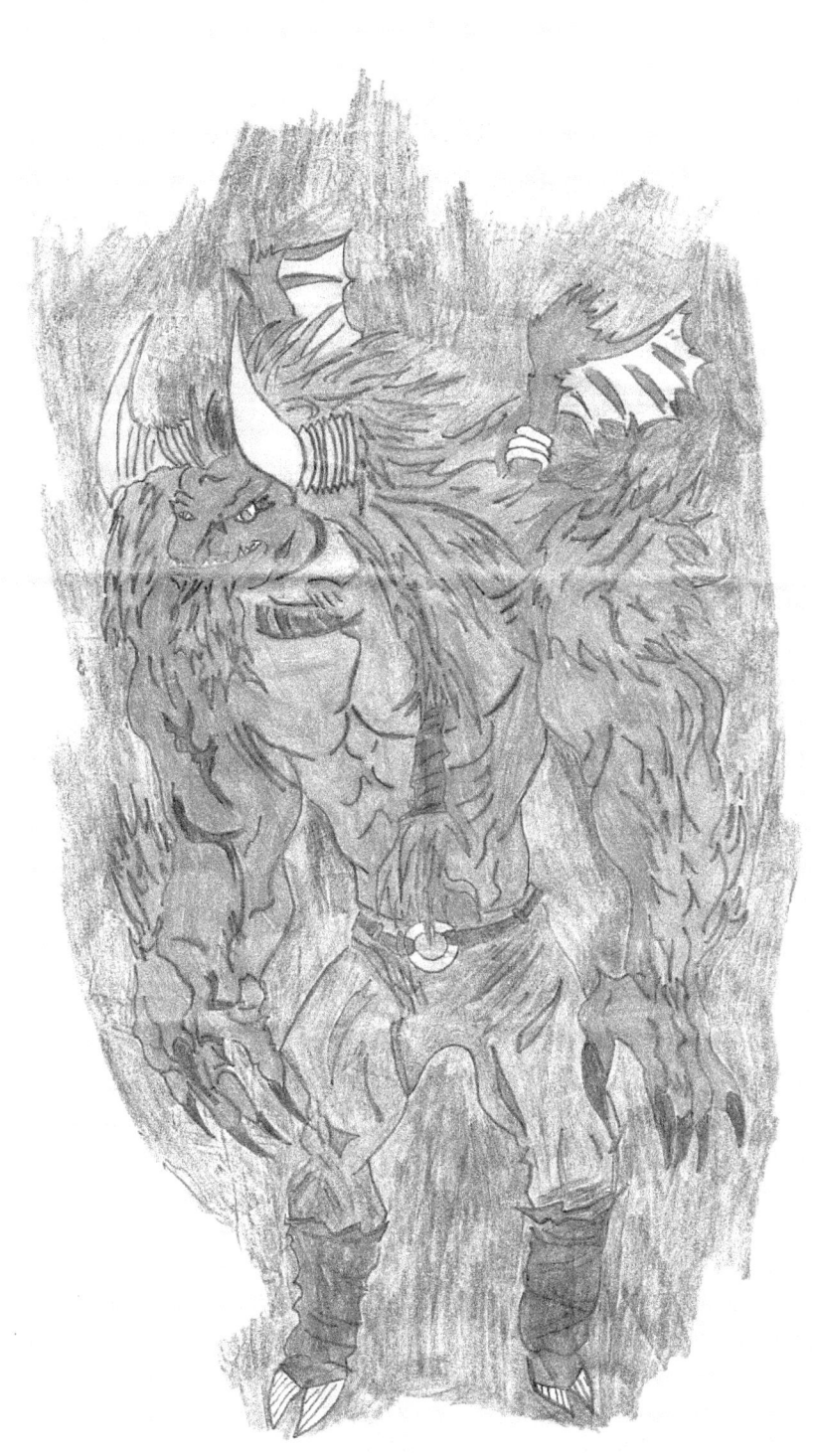